The

Alabama
Angels

The
Alabama
Angels

Mary Barwick

With Illustrations by the Author

Ballantine Books • New York

This edition originally published in two volumes by **The Black Belt Press**,
a division of Black Belt Communications Group, Inc., in 1989 and 1991.

Grateful acknowledgment is made for permission
to reproduce the following paintings:
Page 44: In the private collection of Patricia Uhlmann
Page 46: In the private collection of Kristen Shrove
Page 54: In the private collection of Laurie Weil
Pages 56 and 60: In the private collection of
Mr. and Mrs. Calvin Cherry, III

Library of Congress Card Number: 93-90210

ISBN: 0-345-38574-8

Cover design by Kristine V. Mills
Design and Composition by Randall Williams and Cindy Noe

Manufactured in the United States of America

First Ballantine Books Edition: November 1993

10 9 8 7 6 5 4 3 2 1

Contents

THE
Alabama
Angels

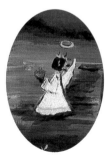

It is dedicated
to the spirit of love
within us all
and to my family
who has given me
"roots and wings."

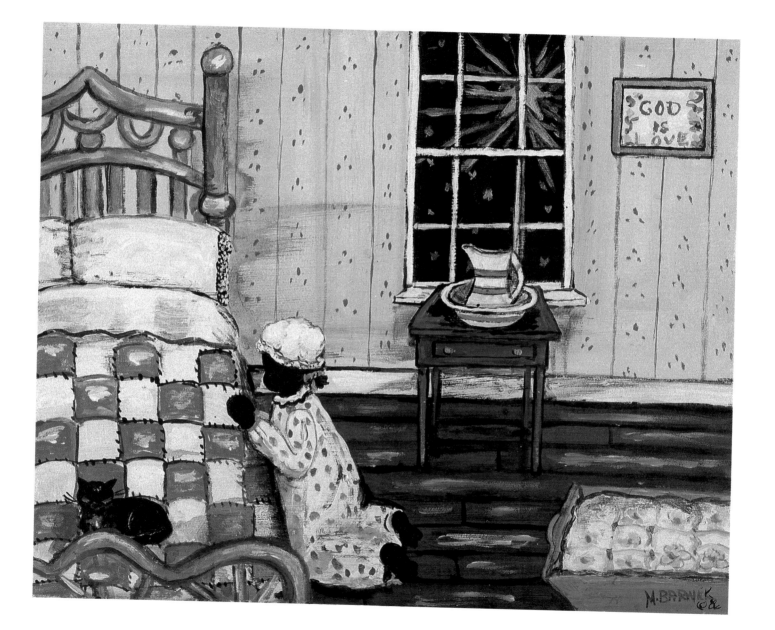

IT WAS a crisp fall night in Alabama. Wisps of smoke curled from the chimney of the tidy cabin. The velvet sky held a sliver of moon and myriad stars. The cotton was high in the fields and the livestock slept peacefully.

Alethea knelt by her old shiny brass bed, with the treasured quilt her Mama had made, praying her best to a God she wasn't sure was there.

"Please, if you're listening, help my Mama and Daddy. They are fine folks. They work so hard and they're always talking about you; like you're friends. If you're still listening, they sure could use help. The cotton needs tendin', there's washin', ironin', animals to be fed, and Lord, all kinds of things to be doin'. My Mama says there aren't enough hours in the day. Could you manage a few more? Thank you, goodnight."

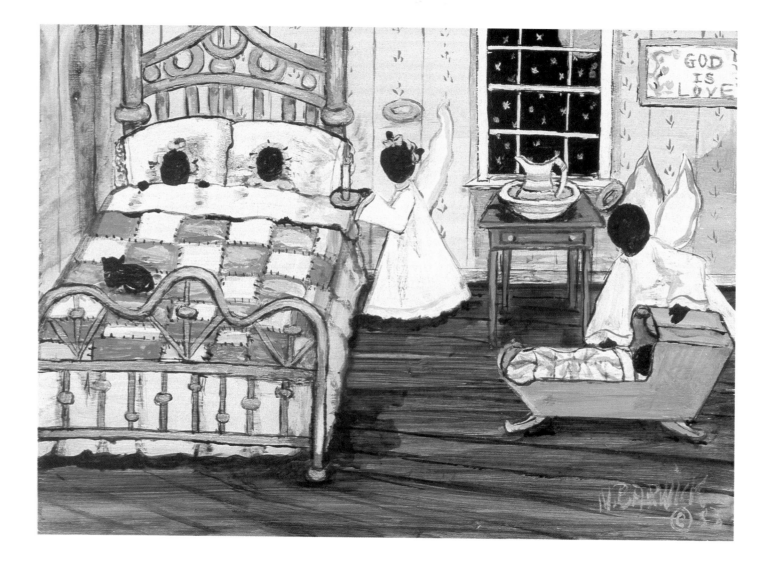

The Lord was listening as He always does and He smiled. Alethea wasn't the only one asking for that lately. He thought for a minute and He knew how He could help His good children who worked hard and cared for each other.

He sent for Bubba, who was one of his special angels reserved for Southern assignments. Bubba came flying. "Yes, Lord, you wanted me?"

"Bubba, I have a problem with my Alabama folks. They have more chores than they have hours in the day. Do you think you could round up some Southern angels and go to Alabama and help out during the night, lightening the load of those grand folks?"

"Oh, yes, Lord, I'll get Sara, Emily and some others and we'll be back in Heaven before the rooster crows."

Bubba, Sara and Emily's first stop was Alethea's house. They peeked in on her and her sisters as they slept.

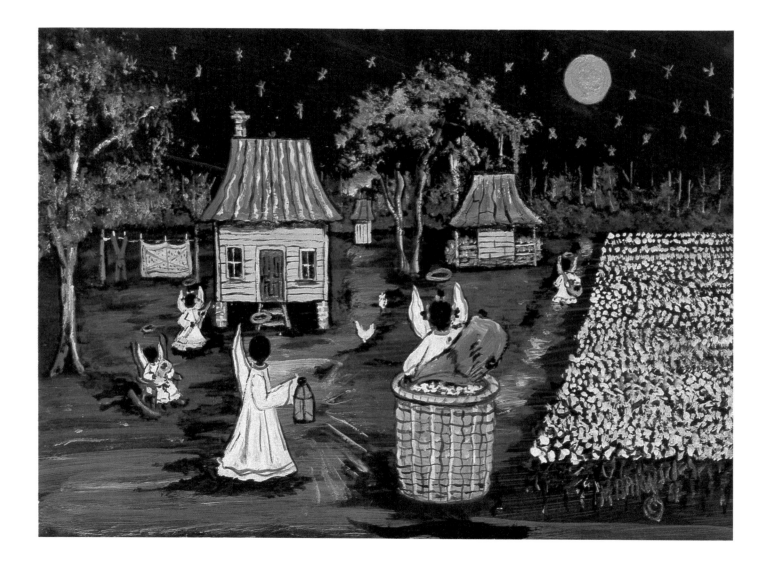

Then they went to pick the cotton, wash some clothes, and rock the baby. They left just in time to beat the sun.

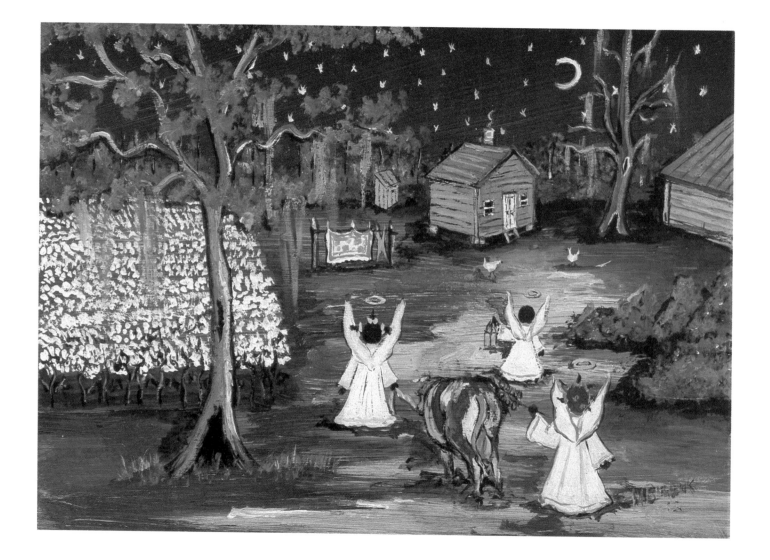

On their return the Lord was so pleased with their errand that He gave them their next assignment. It was to deliver a cow to a family in Selma. Theirs had been struck by lightning and five little children were depending on its milk. They had just asked the Lord to help them.

When the Alabama angels got home the Lord hugged them. His people were thanking Him more than ever.

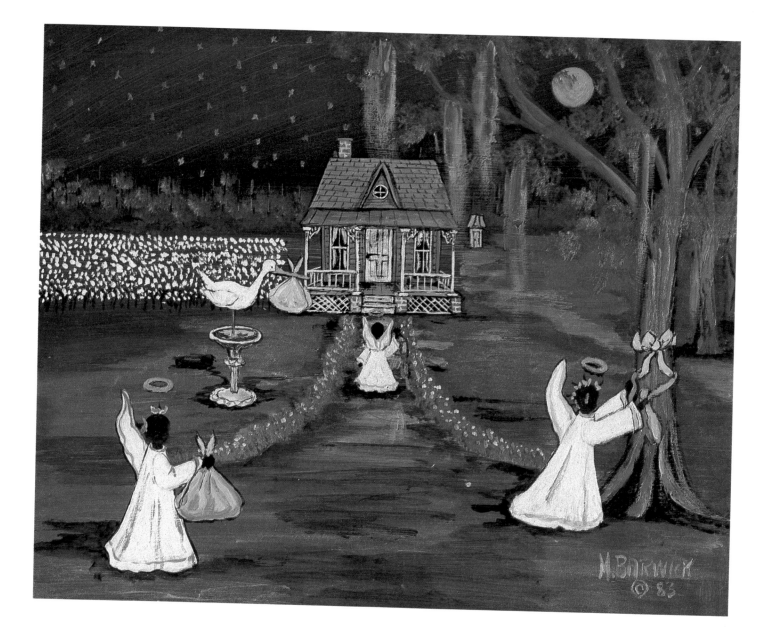

Bubba and the others could hardly wait to see what the Lord had in store for them next. It was so exciting traveling from Mobile to Gadsden, from east to west. They even helped an aging stork deliver twins to a dear family in Eufaula.

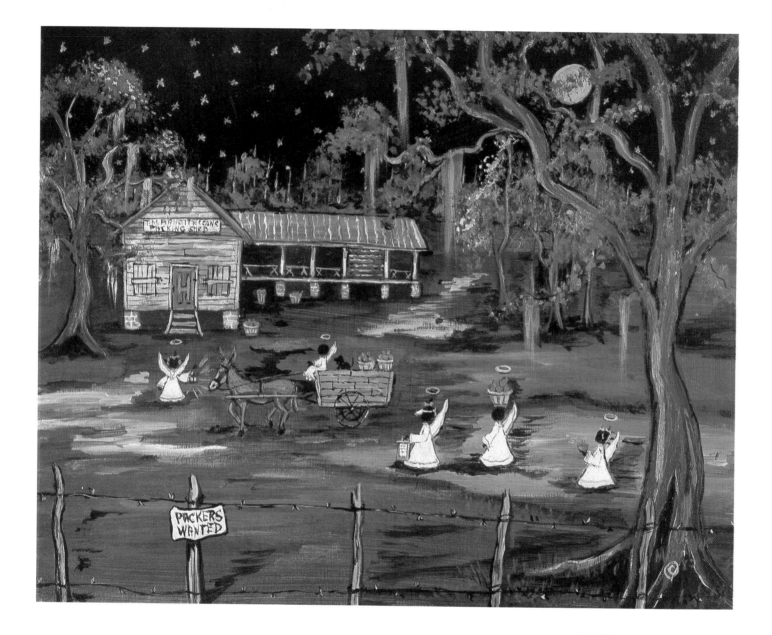

In Slocomb, an abundant tomato crop proved too much for the local packing shed workers, so the Alabama angels helped ready the tomatoes for shipment.

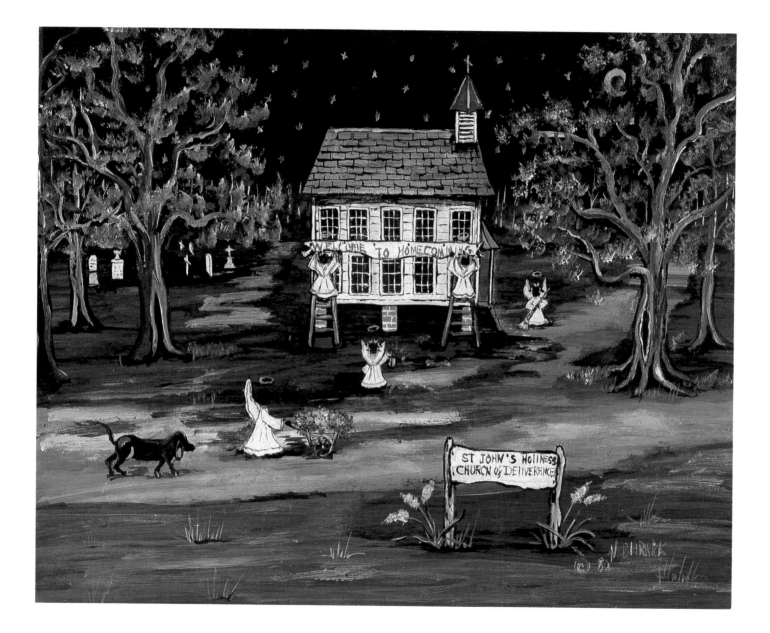

Homecoming at a small country church went without a hitch after the Alabama angels pitched in to do the last minute chores when the preacher got the flu.

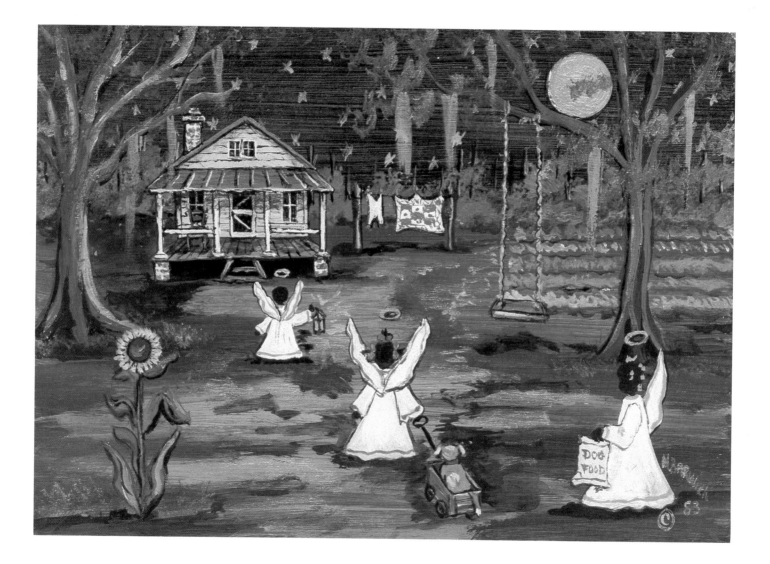

Bringing a wished-for
puppy to a little Tuskegee boy
delighted them as they
watched his happy face from
behind a cloud.

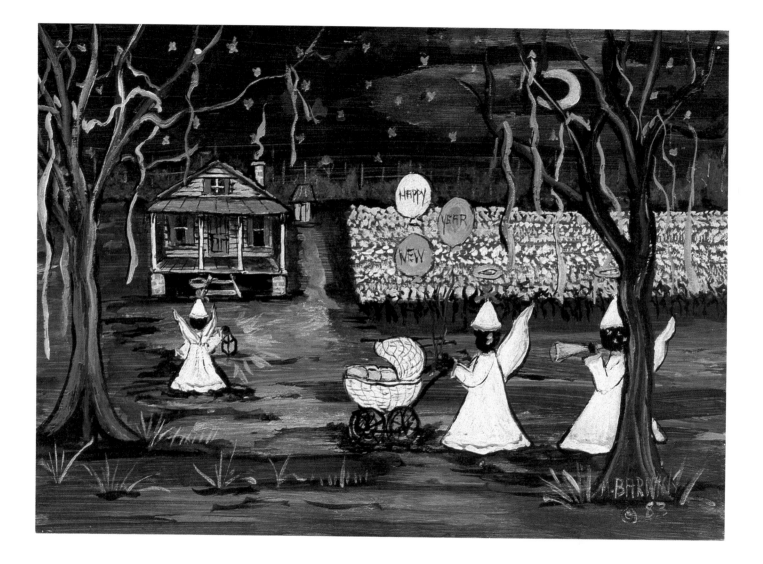

When the Lord told
Bubba that they could escort
the New Year to Opp, their
wings puffed with pride.

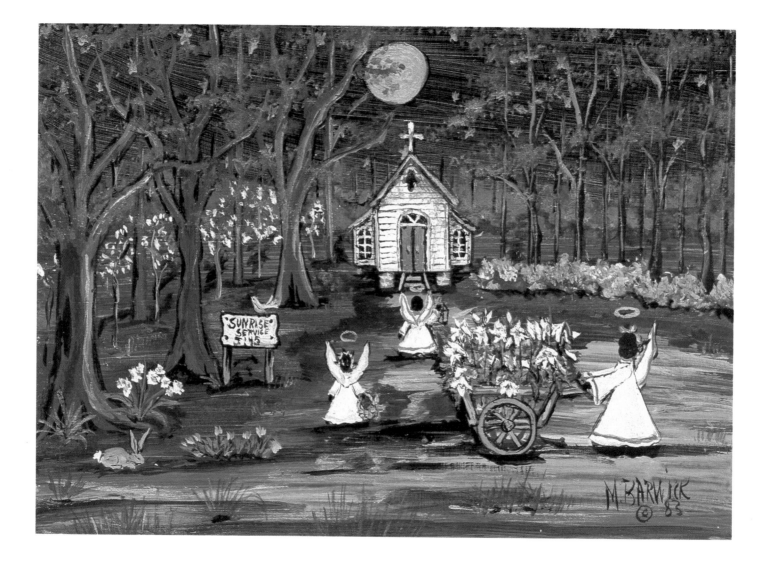

Scottsboro was in a quandary. A late frost had ruined the Easter lilies that were to be used for sunrise services.

Sara and Emily gathered Heaven's finest and, with the help of the others, they had them in place for a glorious Easter Morning.

Meanwhile, Bubba helped the bluebird practice his song.

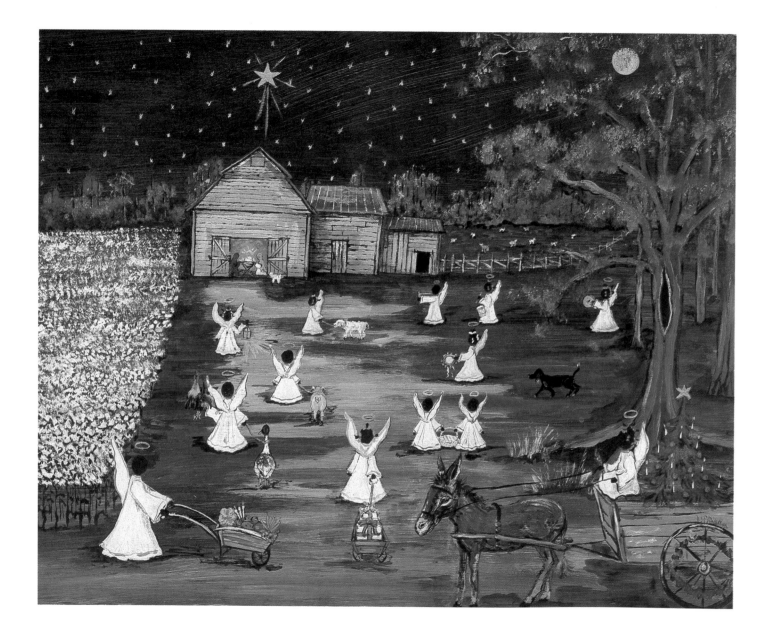

"We know that God makes all things work together for the good of those who love God." (Rom. 8:28). So during the year the opportunities for the Alabama angels to do the Lord's work were numerous.

Christmas is the favorite time of the year for all angels. The Alabama angels delight in finding a special family with a new baby boy. They bring him gifts of love and song to celebrate the birth of Baby Jesus so many years ago. They may be in a rural Alabama community or in metropolitan Montgomery or Birmingham. The excitement is the same because they have the pleasure of honoring the Lord as the angels did in Bethlehem.

Wherever you are in the State of Alabama, when the moon is high in the Southern sky, in the hush of the night you might hear the flutter of wings and the tiptoe of tiny feet. Look carefully and believe.

You will see the glow of magic haloes as they light the way of the Alabama angels.

The End

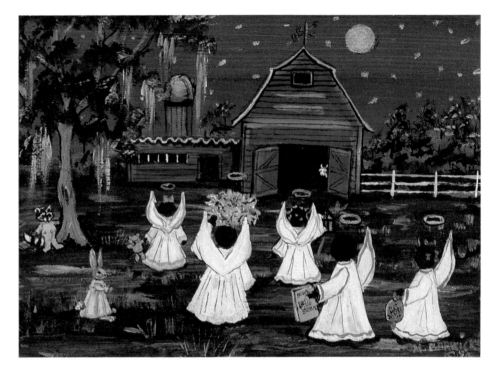

THE
ALABAMA ANGELS
in
Anywhere, Lower Alabama

Dedicated

to the

Presence of Angels

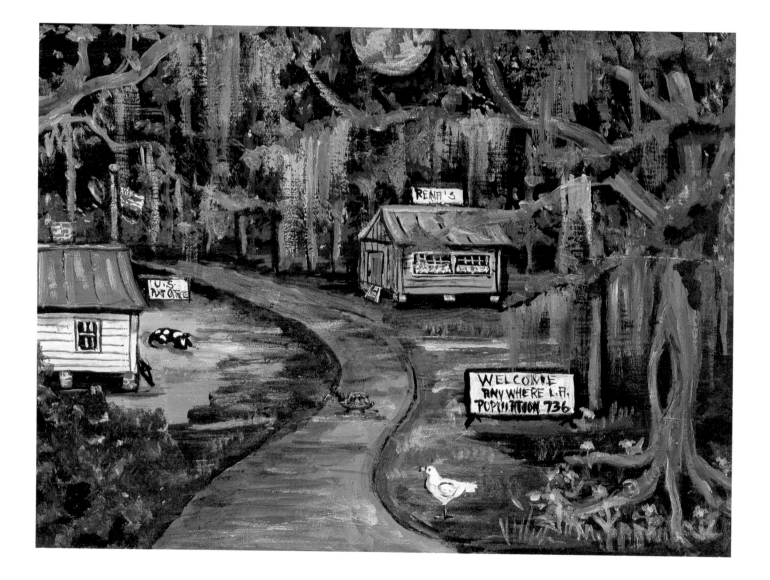

ANYWHERE, L.A., was a tiny jewel in the magnificent setting of rural Alabama. It was evolved over a hundred years as a farming community, made prosperous by the railroad. Generations were raised on the pride in their lush surroundings. Families were born on their land and died on their land. Very few left and if they did, they usually returned. Such was the attraction of Anywhere, L.A.

The change was gradual, barely perceptible. One farm was sold and then another. The "big highway" that was to come near was put fifty miles east and the railroad stopped running through Anywhere, L.A. The sweet land of cotton, once teeming with activity, was becoming hushed. Young people were growing restless and seeking their fortunes in larger towns and cities.

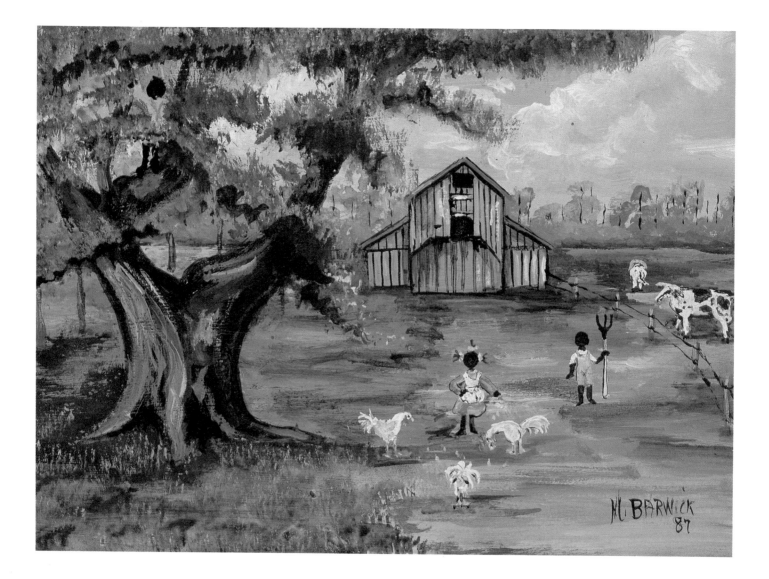

The spirit of the community was experiencing discouragement which can cripple and kill if not quickly dispelled.

Mr. Willie was one of the town's oldest members. His grandfather had cleared the farm he lived on. He built the house and planted the magnolia tree in the front yard. There were notches in the barn door where children's growth had been measured. So much had been invested; so much had been harvested from this good earth.

Now Mr. Willie slept a restless sleep. His dreams were tortured with the possibility of losing the place he held so dear. His son would lose his inheritance as would his children.

He tossed in his rumpled bed seeing Anywhere, L.A., fading into nothingness. The vision was so awful he woke up. Then he began to pray for an answer to his problem. He had prayed before and he really didn't expect anything. He was tired physically and spiritually.

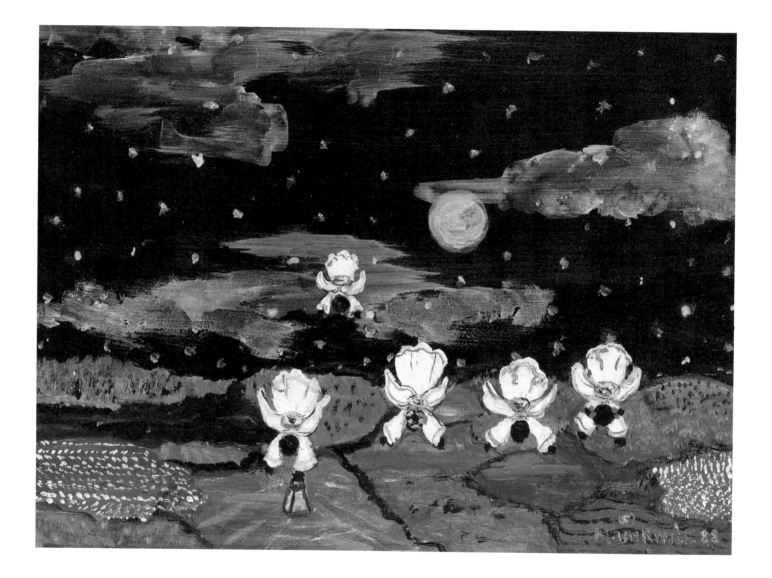

God was listening as He always does. He called for Bubba, who was one of his special angels reserved for Southern assignments. Bubba came flying. He was anxious to help.

God parted the clouds and showed Bubba Anywhere, L.A., and Mr. Willie sleeping his tormented sleep. He directed Bubba to bring him a message.

In a twinkling of a star, Bubba and his Southern angels were beside Mr. Willie's bed. They whispered in his ear, "Get everyone together for a meeting and decide as a group what can be done for Anywhere, L.A. If you love enough anything is possible."

Dawn came creeping up on Mr. Willie. His once-tired eyes felt rested. His once-tired spirit felt exhilarated. What was happening? He looked out on his dew-sparkled farm as if it were brand new. He threw on some clothes and jumped in his truck. He headed to Rena's Cafe where he posted a notice of a town meeting. That was the quickest way to get the most people together tonight.

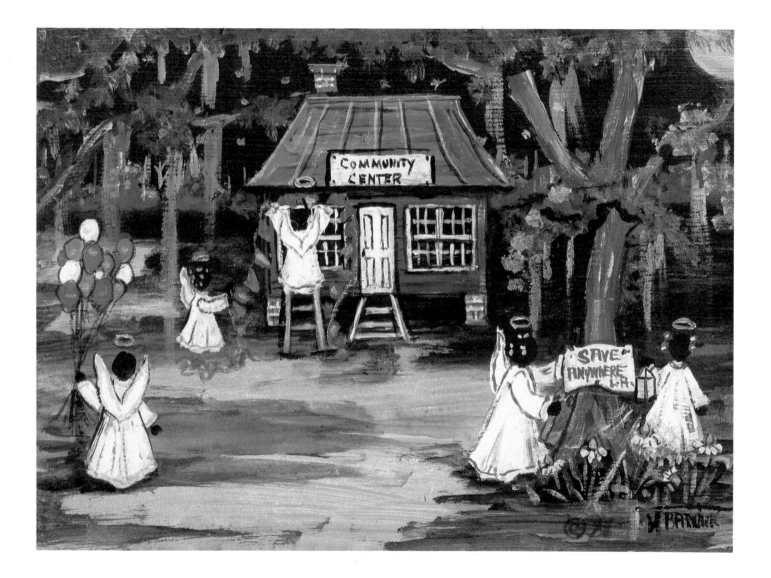

As darkness descended on Anywhere, L.A., the small community center was filled with people trying to guess why they had been gathered. Mr. Willie called the meeting to order and told them about his dream. The bad part, then the good. He said, "It almost seemed like an angel whispered in my ear!" He told them to go home and think of ways that they could come together for the good of the community. They would meet the next night to vote on suggestions. Mr. Willie went home smiling, knowing somehow, with God's help, it would all work out. He slept a peaceful sleep.

While the town slumbered, Bubba, Sara, and Emily were busy decorating the community center for the voting. The electricity of enthusiasm crackled in the night air!

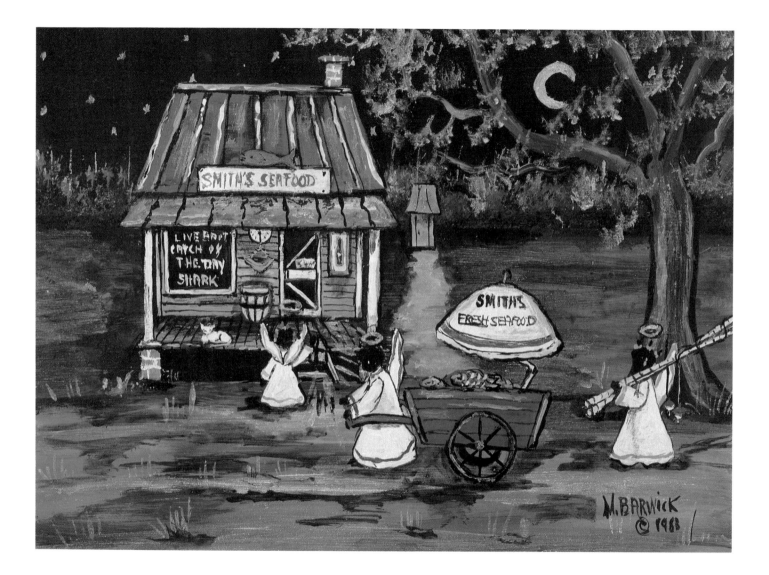

When the meeting began the next night it became apparent that each member had a special talent that, by itself, didn't seem tremendously important, but together, it made up an impressive body of work. Miss Essie Smith was the area's prize-winning baker. Her specialty was pecan pie. Bobby Boudreaux caught the biggest fish and the sweetest shrimp for the fish market. Miss Flora Jean and Miss Charlie Mae made the most beautiful quilts of anyone in these parts.

Lulu Brown was always fixing his famous camp stew for parties and church groups. The town never had any event that Mr. Happy's flowers weren't the centerpiece.

People from miles around recognized that Dr. Payne's animal clinic worked magic with raising superior hunting dogs, not to mention caring for the health of the farm animals. As the people offered their talents for the community, they began to realize that they could save Anywhere, L.A., by leaving it.

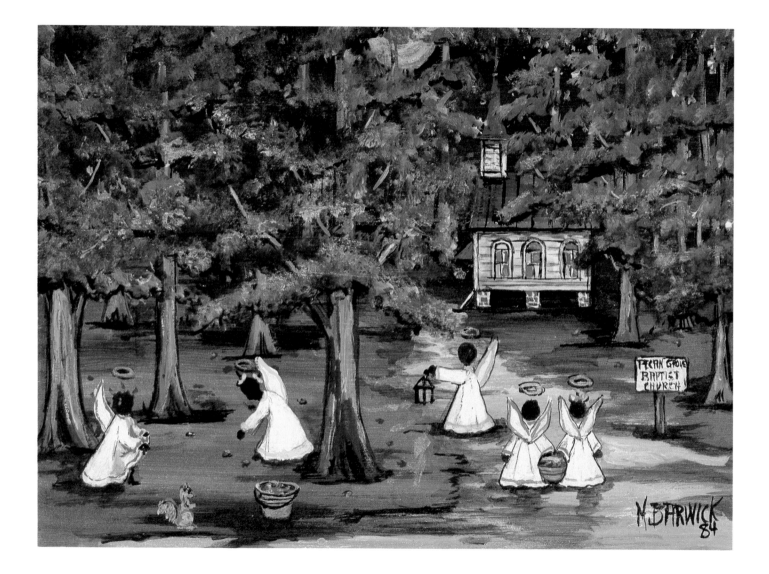

They could go to market day in "Big City" with their wares. They would sell them instead of waiting for the people to come to them. Everyone agreed to go the following weekend.

Each person worked at a "fever pitch" at their specialty. The whole town of Anywhere, L.A., was smiling, but as the days dwindled it seemed like they wouldn't have enough time to have everything ready for the big day.

God was observing his dear people working together for the common good. It was a wonderful sight! Bubba, Sara, and Emily watched, too. They were eager to participate.

Finally they got their flying orders. With a group of Alabama Angels they set out for Anywhere, L.A. The first night they picked pecans and shelled them for Miss Essie Smith's pecan pie.

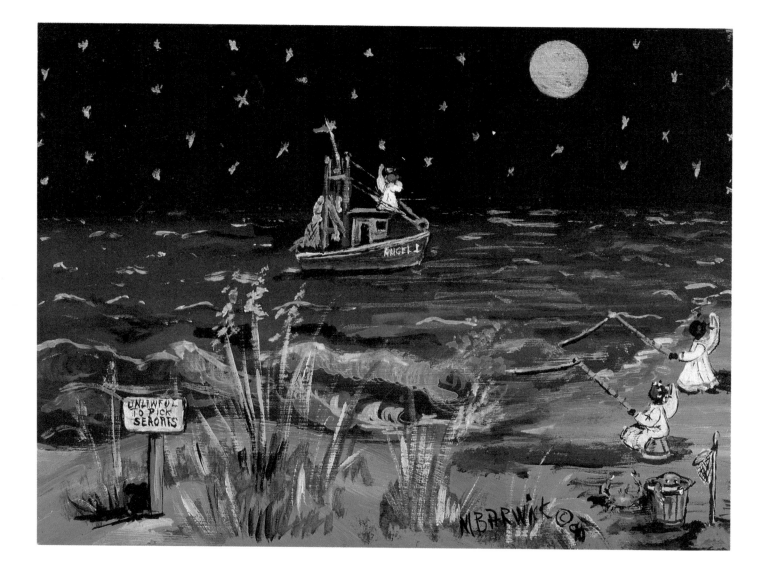

Some angels went into the Gulf and brought back fresh fish and shrimp for the fish market. As dawn approached they headed home, tired but happy after their journey.

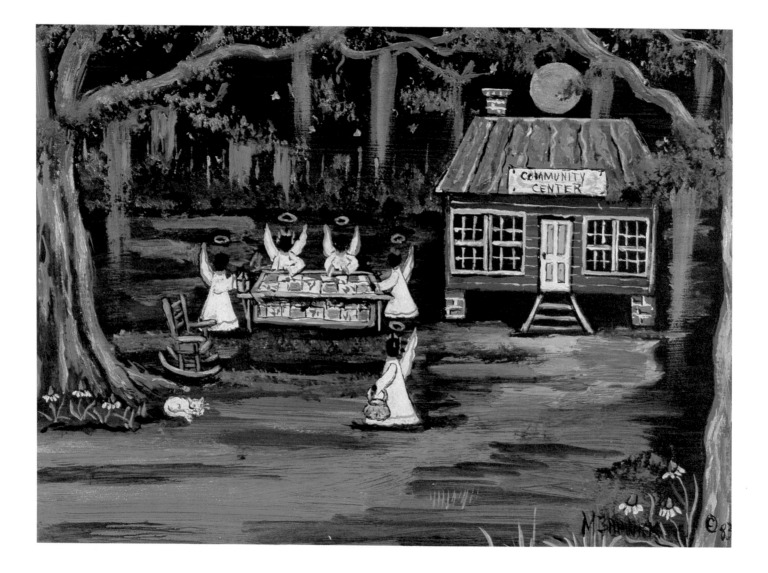

When darkness fell again, the
Anywhere, L.A., folks collapsed in their
beds after their day's work as the night
shift was arriving. Bubba, Sara, and
Emily worked magic on quilts begun by
Miss Flora Jean and Miss Charlie Mae.

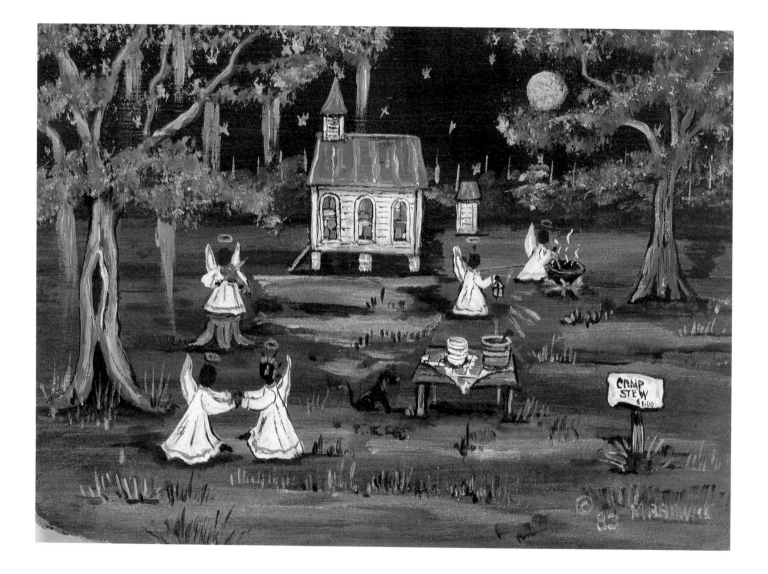

Some other angels took turns stirring Lulu Brown's camp stew. As the sky faded from black to navy blue, Bubba organized the return flight. They fell asleep in God's arms.

Meanwhile everyone was amazed at the abundance of things accumulating and said to each other, "It seems like a miracle."

Market Day was only two days away. Dr. Payne and Mr. Happy were anxious about their responsibilities other than Market Day. Dr. Payne's regular patients weren't getting their usual care because of time spent with the champion Blue Tick puppies he planned to show and sell. Mr. Happy had promised to provide flowers for a wedding up the road. He was so busy selecting the ones for market, he hadn't gotten around to the other.

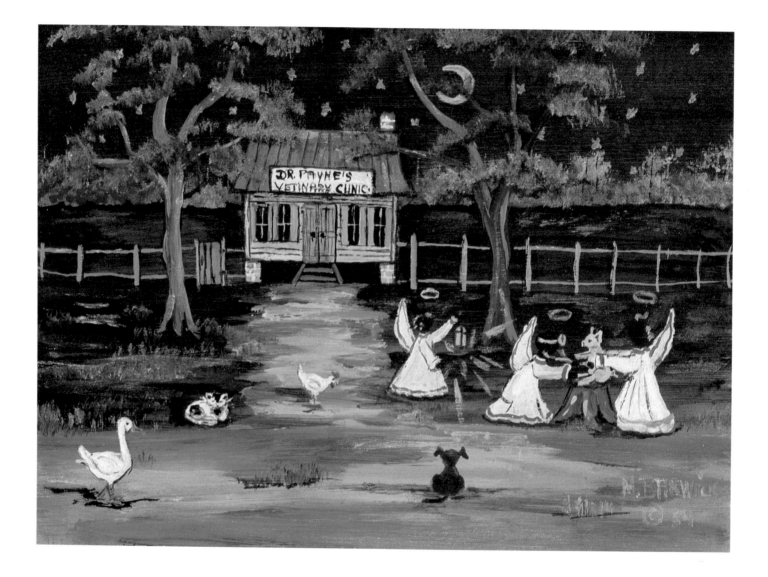

Bubba already had his plans worked out. When God turned on the first star that night, he and his group headed for Dr. Payne's animal clinic.

They enjoyed caring for the animals and the animals were happy to see them.

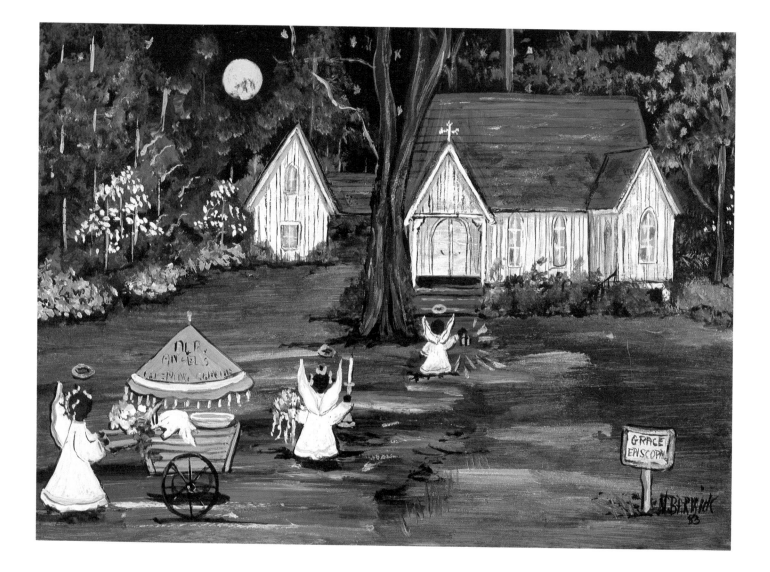

On their way out of town they delivered the flowers to the church as Mr. Happy had promised.

Friday was a busy day. The town was preparing the various means of transporting the goods and putting finishing touches on their things. By evening, all that remained was the packing which they could do in the morning.

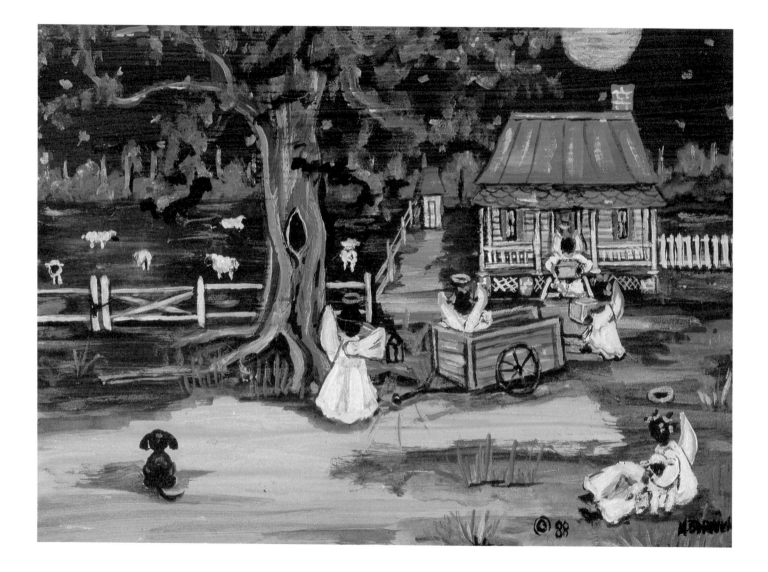

During the night Bubba and company went to each house, carefully packing the treasured items in the wagons and trucks. They smiled on everyone's labors with great pride. The job was finished.

They slept their heavenly sleep and woke to God's gentle voice telling them how successful Market Day had been and all the things sold and orders taken. The name Anywhere, L.A. was spreading fast throughout the state. Mr. Willie could stay on his farm as could the others. With love and faith, Anywhere, L.A., will survive another hundred years.

Bubba, Sara, and Emily danced with delight. The Alabama Angels had done it again! God's special treat for their exceptional mission was a marvelous surprise! He was sending them to the beach for a well-deserved vacation.

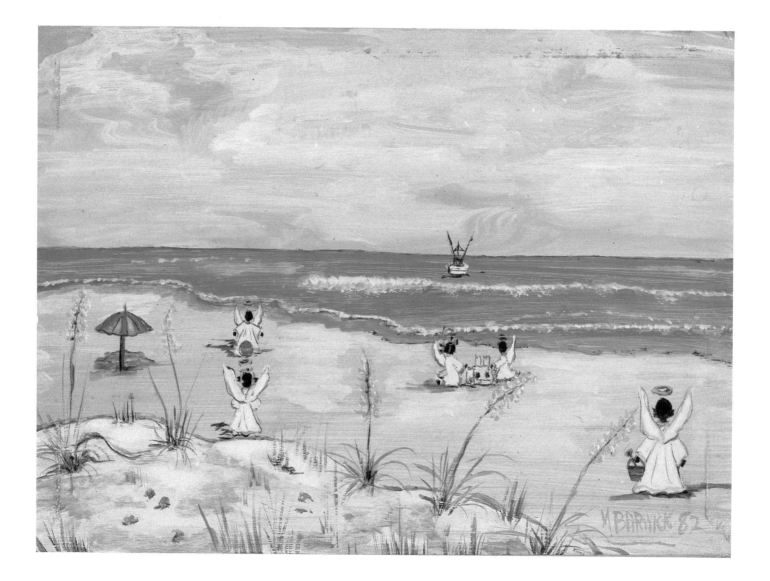

If you're on the Alabama coast early some morning before the rest of the world is awake, you might see the flutter of wings and the footprints in the sand of tiny feet. Listen carefully and believe; you will hear the joy of angels as they talk of helping the Alabama people.

The End

About the Author

Mary Barwick is not only an accomplished painter and writer, she is also a registered nurse. A native of Charleston, South Carolina, she has spent the last fourteen years immersed in the culture of Alabama, and has encountered more than one Alabama angel during her sojourn there.